REBEL STYLE

CINEMATIC HEROES OF THE 1950 s

© 2006 Assouline Publishing
601 West 26th Street, 18th floor
New York, NY 10001, USA
Tel.: 212 989-6810 Fax: 212 647-0005
www.assouline.com

ISBN: 2 84323 751 3

Color separation: Gravor (Switzerland)
Printed by Grafiche Milani (Italy)

REBEL STYLE

CINEMATIC HEROES OF THE 1950 s

G. BRUCE BOYER

ASSOULINE

rebel style brought a completely new attitude and look to the screen of the 1950s. An aspect of "hip," it was the American version of the existential view of life that emerged in the wake of World War II, the atomic bomb, and a society based on conformist consumerism. If this was the fate of society, some made the choice, as Norman Mailer put it, "to divorce oneself from society, to exist without roots, to set out on the uncharted journey into the rebellious imperatives of the self [because] one exists in the present, in that enormous present which is without past or future" (p. 344). That was the essence of hip, and the black leather jacket and provocative stare, the prole clothes and the laid-back stance, and the broodingly cool demeanor of *nil admirari* was its aesthetic correlative. In film, it borrowed from the aloneness of the hero as romantic outlaw in classic gangster and Western genres, like James Cagney in *The Public Enemy* (1931) and Gregory Peck in *The Gunfighter* (1950).

Of the four newborn film rebels of the day—Marlon Brando, Montgomery Clift, James Dean, and Paul Newman—only Newman's career fulfilled the promise of his bright beginning. Brando lived to be eighty, but his fame rests on a handful of films made mainly in the 1950s. Dean's career as a film actor spans a slightly-less-than-twenty-month period from March 1955 to October 1956. Clift was forty-six when he died, leaving sixteen films, not all of merit.

And yet each had an incredible impact, not only on the future course of film, but on the culture as well. Marlon Brando was the model for the other rebel acting icons of his time, as well as the inspirational godfather of Al Pacino, Dustin Hoffman, Robert De Niro, Sean Penn, Tim Robbins, Johnny Depp, and other actors who practice their craft with an eye to the powers and subtleties of realism, and who have all in their turn been labeled with the title of "the New Brando."

brando's film career was as unusual and singular as he was. He was not yet thirty when he played Terry Malloy in *On the Waterfront* (1954), which marked the zenith of his career. After making more than a dozen mediocre films in the following years, two unexpected bright points came to Brando with *The Godfather* (1972), for which he won, but refused to accept the Oscar for Best Actor, and *Last Tango in Paris* (1972). But that was the end of Brando's great roles, and he did little of consequence thereafter. Just a handful of films made him an icon. He was an original, the American rebel and existential blue-collar hero. He exuded a raw, sexual power, and had a seemingly

intuitive naturalistic acting style that shattered the pleasant conventions of American popular culture when he first appeared onstage and later in films. Brando was both irresistibly sensual and darkly threatening as he epitomized personal freedom at a time when conformity was held in high societal esteem. In his portrayals of Stanley Kowalski, Johnny the biker, and Terry Malloy, the rebellion was social and philosophical rather than political, and the characterizations reflected a psychological restlessness and dissatisfaction with the values of middle-class American life. Perhaps the most obvious sign of this rebellion was the sneer. Insolence in the form of a facial gesture was virtually a trademark, and was, in some cases, such as Elvis Presley, a caricature of the icon's facial "pose."

brando rose to fame in a postwar society of illusion-shattering awareness of a larger world bound together as much by fear of horrifying destruction as by honorable alliances. Society itself was cleft by rebellion against a growing conformity by the new poets of the American vernacular, as well as by the emergence of black music in white teenage culture. The rebel as icon came to include Marlon Brando, Jack Kerouac, Elvis Presley, and, of course, James Dean. They were all members of the new realism in art, the Beat generation, and rock 'n' roll, renouncing the puritanism and conventionality of the period. In *The Wild One* (1953), Brando's pebble-kicking stride, his insolent sneer, the rakish angle of his cap, and casual straddle of his bike, identify him as a challenger of society's values. In truth, Brando and the other disaffected heroes of

the time were mostly rebels without a cause. In *The Wild One*, when Brando's character, Johnny, is asked, "What are you rebelling against?" he answers, "What've ya got?" This was part of a cultural revolution that pitted the prewar generation against its rebellious postwar children, not unlike the Jazz Era that arrived with a syncopated trumpet blast after the 1918 Armistice ended World War I.

after World War II, the burgeoning middle class looked in two different directions for the more outward manifestations of style: either to a version of the Eastern WASP Establishment for the traditional business uniform and the slightly more casual Ivy League attire; or to the underclasses, which favored the more heady and urbane zoot suit or the rural motorcycle/blue-collar look. Most middle-class young men—particularly those who had been in the army and enrolled in colleges through the economic incentives of the GI Bill—looked to the Eastern Establishment for inspiration. As epitomized in the film *The Man in the Gray Flannel Suit* (1956), Establishment dress was the somber business uniform of corporate America in an era of understated power. The purposefully casual role of the button-down shirt collar and affected negligence of the shapeless prep-school sack suit were the favored uniform of Wall Street, Madison Avenue, and Pennsylvania Avenue.

Black and Hispanic youth preferred the zoot suit in the 1940s. Charlie Parker, Dizzy Gillespie, Miles Davis, and other jazz musicians who formed the bebop jazz movement wore versions of the mid-thigh-length jackets with superwide shoulders and billowing

trousers, the "drape shape with the reet pleat" hepcat look. The drape was popular with jazz fans of any racial makeup because it was cool with street hustlers, gamblers, hoods, and working-class youth, and as such crossed over from one ghetto to another. For part of his wardrobe for *Somebody Up There Likes Me* (1956), Paul Newman—as the street-smart young tough Rocky Graziano—wore a striped zoot suit, accompanied by a T-shirt, a sports shirt, and a porkpie hat set flat on his head with the brim turned up all the way around. The style of the hat alone indicated to one and all that here was a character in rebellion, asserting his style in a world he never made, nor would ever have much part in. Newman was the epitome of the urban hipster, the slum prince of his own making who transcended bourgeois sentimental emotion and remained cool, collected, and loose in his approach to the brutality and horrors of ghetto existence. The zoot suit, worn defiantly by the wily underdog, was the blatantly exaggerated armor of resistance and denial.

a lthough both black and white rock musicians started off wearing various regional versions of the zoot suit in the early 1950s, most white rockers eventually came to identify with the prole gear of the era (of which Presley's 1968 comeback appearance on TV stands as caricature). Revolutionary periods tend to share an attitude of provocativeness that enters the culture as style. In less than ten years, T-shirts and jeans became globally identified with rock bands, which always considered themselves to be rebels anyway, and wanted desperately to be thought of as threatening to the social order. In the movies, the leather jacket completed the look; it

9

became a gleaming second skin for the new generation. It originated, both practically and symbolically, as protection, but quickly grew into a revolutionary attitude of insolent dissent, one which stated that rebellion for the sake of rebellion had its own style and importance.

t he new rebel of the 1950s epitomized the dark side of the American dream, which developed in opposition to the growing feeling of prosperity that spread in the U.S. after World War II. Indeed, a growing unease and ferment arose, from those on the bottom rungs of the ladder, from political and social radicals, and especially from a group new to challenge society: teenagers. This was the beginning of a rebellion against what was perceived as a lockstep saccharine culture, a rejection of a new corporate-guided consumerism; a postwar schism was emerging between the man in the gray flannel suit and the rebel. John Leland notes that 1955 was truly a watershed year: Ray Kroc, founder of the McDonald's hamburger chain, opened his first fast-food franchise; *Rebel Without a Cause* was released; and Elvis Presley appeared on TV for the first time. Parents who saw Presley perform on those first shows said, "What the hell was that?" But the teenagers knew, and rock 'n' roll became a national force.

The Beat poets railed not only against white-collar consumerism, corporate culture, and suburban living, but against the traditional language of poetry itself. In 1955 a young Allen Ginsberg published *Howl*, an epic poem in which the language seemed broken and the images horrid. It became the anthem of the Beat generation:

"I saw the best minds of my generation destroyed by madness, starving hysterical naked, dragging themselves through the negro streets at dawn looking for an angry fix, angelheaded hipsters burning for the ancient heavenly connection to the starry dynamo in the machinery of night..."

—Howl, ll.1–3

The inheritors of the experience of two world wars and a soul-numbing economic depression, all within a quarter of a century, searched for new meaning to a human experience increasingly cut off from the traditions of the past. The angelheaded hipsters of the new culture were striking a loud note of discord in this growing garden of affluence, struggling against the self being swallowed by state regimentation, and showing distrust even of the traditional forms of language to convey meaning. This was particularly strong in the cinema, where new movie heroes were often portrayed as so many mumbling Hamlets, doomed to a sort of madness in a world they were cursed to try to set right.

at the time, Brando, Clift, and Dean particularly attracted the attention of the young moviegoing public with their sensual handsomeness, their revolutionary acting styles, and the unconventionality of their lives. Brando was Dean's hero, but all three actors were introverted loners brought up in dysfunctional households, and all had an incredibly difficult time coming to terms with their fame.

Brando and Dean were born in the Midwest, and both had erratic fathers who did not provide much stability for their families. As boys, they were troubled and unruly, and were often thought of as

11

pranksters. As young men, they had no learned skills and took a few odd jobs before drifting to New York City and into the Greenwich Village scene, a cauldron of creativity in those years after the war. Both attended classes at the newly formed Actor's Studio, and would forever incarnate the hero caught in a struggle between sensibility and a deep sense of the absurd.

t he sense of alienation budding in the films of the period was also a consequence of dramatic realism—a movement that began in small inner-city theatres in the 1930s, championed by the politically active Left—coming into its own. It was, in many respects, a theater of protest, and when Brando was cast as Stanley Kowalski in Tennessee Williams's *A Streetcar Named Desire* (which debuted on Broadway in 1947), he consecrated the new interaction between desire, social codes, and honesty. He was "the hoodlum aristocrat," according to director Elia Kazan, challenging "the whole system of politeness and good nature and good ethics and everything else" (Schickel, p. 32). It was an assault, not only on the accepted style of acting, but on the manners and morality of the entire society. And Brando embodied the whole iconography of the rebel style. Between *Streetcar* and *The Wild One* (1953)—a film that clearly shows the opening chasm between the middle class, concerned with refinement and decorum, and the outsiders who show their distain for the status quo—Brando perfected his sardonic image. He invented the first popular treatment of the hipster, and his sartorial symbols of rebellion are still with us today (co-opted, of course, by designers). Hollywood was quick to exploit and disseminate the prole look, and as social critic Diana Crane has

noted, "items of clothing that were worn in films . . . have acquired meanings associated with these forms of popular culture" (p. 181). Brando gave the T-shirt a big symbolic boost of raw machismo in *A Streetcar Named Desire* (1951) and *On the Waterfront*. The jeans, T-shirts, and leather jackets of various marginalized groups (such as bikers) "acquired connotations of revolt—freedom, equality, and classlessness—against the dominant cultural values" (p. 176). American cultural rebels—Brando, Dean, Kerouac, and, of course, Elvis—assumed the iconic dress codes of the underclass in the same way that cowboy and big-city gangster clothes had taken on mythic proportions for an earlier generation in the 1930s and 1940s. Prole gear became the uniform of a new social class: the juvenile delinquent. In *Rebel Without a Cause*, a police detective says to Jim Stark, "Where's your boots, boy?" referring to the thick black leather, double soled, calf-high boots worn by teenage gangs.

montgomery Clift, the anti-macho rebel, had worn a World War II leather pilot's jacket with a white T-shirt and army khakis while playing George Eastman, the poor young man who hitchhikes to the big city to get a job in his rich uncle's factory and win a place in respectable society in *A Place in the Sun* (1951), the first film to capture the struggle between proletariat and bourgeois culture within the individual. Thousands of these brown horsehide jackets—with shoulder epaulets, zip fronts, waist-high flapped pockets, and elasticized wool waistbands and cuffs—had been made by the Willis & Geiger and Schott companies for the U.S. Air Force during World War II. Along with army-issue khaki

trousers, and an inexpensive T-shirt, the bomber jacket, as it was called, was a standard outfit for a young man demobilized after the war and of impoverished means. Army and navy stores sprung up all over the country, taking advantage of the glut of war clothing surplus on the market. Everything from white and olive drab underwear to thick brown leather garrison belts, khakis, peacoats, field parkas, campaign boots, bell-bottom trousers, and all sorts of military headgear was available for almost wholesale prices. The outfit Clift's character wore at the beginning of *A Place in the Sun* indicated that he was something of a drifter near the bottom of the social ladder, an alienated laborer in almost classic Marxist terms, too poor to wear anything but war surplus. Clift's sensitive portrayal prevented the merely disturbing image from becoming either pathetic or shocking. The more shocking aspects of leather and T-shirts came three years later.

brando's portrayal of Johnny the biker was about as unsettling as middle America could stand. "Where'd that bunch come from?" asks the sheriff of the small Californian town that Johnny's rough-clad bikers invade in *The Wild Ones*. "Everywhere," answers the gas station attendant, "but I don't even think they know where they're goin'." But "where" wasn't the point. It wasn't the future that Johnny and company were concerned with; it was the present. And that was as frightening as anything could be to a middle-class audience envisioning a bright, stable future. The repudiation of their dreams was shocking and angering. These hoodlum rebels had an attitude of unfeeling rejection for hard-earned middle-class values.

It could be clearly seen in Brando's sneer of indifference and contempt, later parodied by Elvis as a form of titillation. And Brando's outfit in *The Wild One* said it all. Johnny is first seen roaring into town hunched over a powerful motorcycle, wearing the garb of a prole warrior leader of the pack: black leather waist-length jacket, ornamented with a dozen pockets, snaps, and zippers; a muscle-straining T-shirt with a dark band at the neck; tight, fitted jeans, slung low on the hips with a broad leather garrison belt and large metal buckle, and rolled at the bottom to reveal dust-covered, black leather engineer boots, strapped and buckled over the instep. Around his right wrist he wore a thick-link chain ID bracelet instead of a watch. Johnny was the outcast cavalryman, complete with a visored cap set at a jaunty angle of distain and aviator sunglasses: a hard, impregnable shell of an exterior, worn to tell the world he was both protected and defiant. He didn't ride into town to save the righteous citizens from the bad guys, a common theme in Westerns; he *was* the bad guy.

brando's popularity marked a unique moment in cinema, as he was the best example of the artist-rebel. He was the first to personify the raw, low-browed hero, as offhandedly described by Brando-as-Stanley to Blanche in *Streetcar*, in a nice bit of Tennessee Williams's understated-but-barbed humor, as: "I guess I'm gonna strike you as being the unrefined type." Although until the mid-twentieth century, going back at least six centuries, fashion emanated from the top of the social scale and then filtered down as clothes were handed from master to servant, the angry young rebels of the 1950s invented a

new way in which fashion would operate: from the bottom up. Instead of filtering down from the court and the manor house to the servants and peasants, fashion would now bubble up from the streets. Street clothes, i.e. those work clothes worn by ex-GIs, cowboys, farmhands, and industrial and outdoor laborers, and ethnic dress assumed by second-generation working-class immigrants—army surplus, cowboy gear, gangster suits, bowling shirts, mechanic coveralls, sweatshirts and warm-up jackets, lumberjack shirts and farmers' field coats, navy peacoats, campaign boots, garrison belts, olive drab T-shirts, CPO wool shirts, watch caps, bomber jackets, cargo pants, ranch jackets, carpenter pants, and baseball caps—have all proved fertile ground for designers. And in this respect, the invention of casual clothes within the American lifestyle was partially a product of the section of the postwar generation that felt alienated from the dominant society.

today, of course, the unrefined type is exactly what *is* wanted: the classically cool look of working-class nonchalance. No designer collection would be complete without denim jeans (torn, patched, ripped, sandblasted, acid-washed, or otherwise technologically distressed), black leather jackets, and T-shirts (with or without printed messages). But in the hands of Ralph Lauren, Tommy Hilfiger, Giorgio Armani, Calvin Klein, or Helmut Lang, the black leather jacket—reproduced in every detail though it may be—is a mere shadow of its former self in terms of its ability to threaten or even show moderate disdain for social norms. The outlaw iconography has been diluted to the point of being merely role-playing. Like wearing purposefully distressed jeans, or army camouflage fatigue pants

for casual urban wear that today is favored by fashionistas, these rebellious symbols now speak ironically of their former power.

The designer facsimile is an emasculated offspring of its more virile parents. In their tamer mode, the T-shirt, jeans, and leather jacket have evolved into a pose of nonconformism. Having shucked off their more powerful meanings, they are now a mere romantic sentiment, a *nostalgie de la boue* of nonconformity and insolence, rather than the potent sartorial symbols of arrogant defiance and dangerous rebellion they once were. The rebels have moved on to hip-hop wardrobes, that oversized look which seeks to echo the prison silhouette of young gangstas, and is so reflective of the jazz musicians' zoot suits of the 1940s. Or to vintage Mao, punk, reggae, revival mod, industrial high-tech, and whatever the "cool hunt" sees as the next style to vie for the allegiance of the young dissidents who probably have little idea that there is a bit of Brando in all of them.

a nd, of course, it is in cinema that the legitimate heirs to this important generation of actor-rebels are found. Both Robert Blake and Dennis Hopper, the oldest of the iconographic offspring, built on the brash-defiant-dangerous portraits created by Brando and Dean in their roles as outlaws in *In Cold Blood* (1967) and *Easy Rider* (1969), as did Martin Sheen in his embodiment of killer Charles Starkweather in *Badlands* (1973). But the three actors who have carried on the rebel tradition in image and idea most memorably are Steve McQueen, Jack Nicholson, and Sean Penn. McQueen's style—in such films as *The Magnificent Seven* (1960), *Hell Is for Heroes* (1962), and *The Great Escape* (1963)—personifies to perfection

the brooding loner who presents an image of freedom through nonconformity. His interpretation of the rebel cop in *Bullitt* (1968) shaped the character of Clint Eastwood's loner-rebel cop Dirty Harry Callahan. Jack Nicholson also seems to have made a career of nonconformity in his choice of roles. But his earlier performances, from *Hell's Angles on Wheels* (1967)—a motorcycle-gang film like *The Wild One*—and *Five Easy Pieces* (1970) to *Chinatown* (1974) and *One Flew Over the Cuckoo's Nest* (1975), are studies, as critic David Thomson points out, "in subversive vitality" (p. 651). Whether he is wearing workingman's clothes, aviator sunglasses, or even a film noir-styled suit and fedora, Nicholson is the epitome of cool.

O
f the contemporary breed, it is Sean Penn who most reminds us of the era of Brando, Clift, Dean, and the early Newman, both in his characterizations and his influence. With such films as *Bad Boys* (1983), *The Falcon and the Snowman* (1985), *State of Grace* (1990), *Dead Man Walking* (1995), and *Hurlyburly* (1998), Penn has become an icon for other actors of his generation. As Thomson notes, "he is maybe the only actor who, in interviews, can summon up the tortured introspection of early Method actors without irony or shame . . . He has acquired the hangdog glamour of a rebel" (p. 692).
The intertwining of such actors' images and roles with their personal lives gives them the "aura of apartness," in critic Graham McCann's apt phrase, which puts them firmly in the tradition of the alienated individual at war with society. But these postmodern children of the 1950s rebels do not seem to have the icon-making power of their symbolic fathers (although it must be

said that film also no longer commands the mass audience it did a half century ago). The rebels of today are rebels in content, but a certain attitude was lost along the way. Their approach to their craft fills their performances with a raw power, tension, and psychological sensitivity that continues to give realism new dimensions, but insolence, this miraculous corollary of freedom, is gone. The truth is, Brando and Dean will probably remain the touchstone images of the rebel: they gave a face to the rootless and moving voice of the common man.

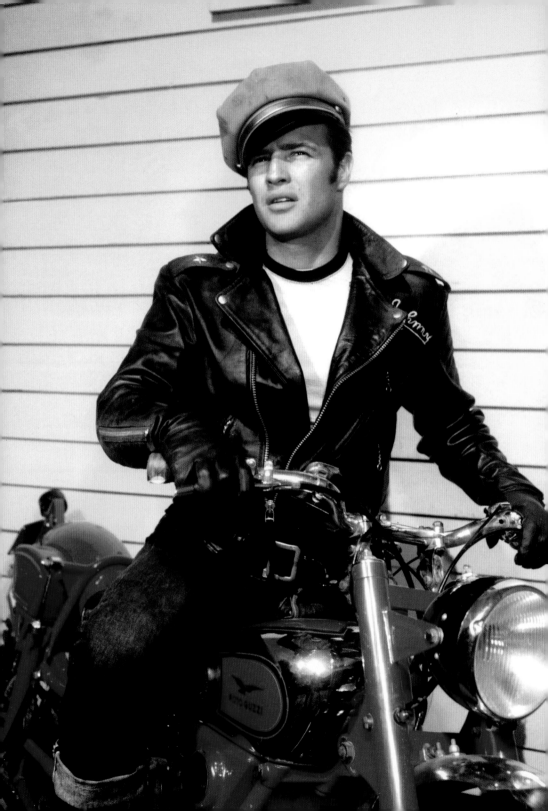

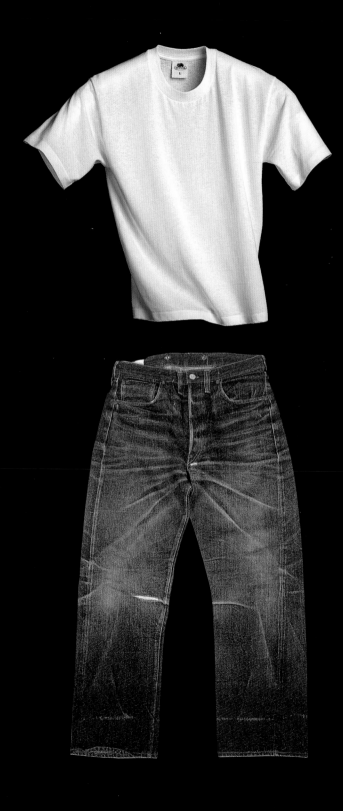

The reception committee for the new kid on the block!

JAMES DEAN

The overnight sensation of 'East of Eden'

Warner Bros. put
all the force of
the screen
into a challenging
drama of today's
juvenile violence!

"REBEL WITHOUT A CAUSE"

In CINEMASCOPE
and WARNERCOLOR

...and they both come from 'good' families!

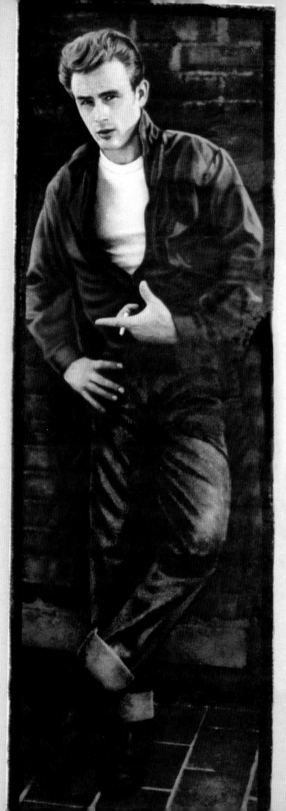

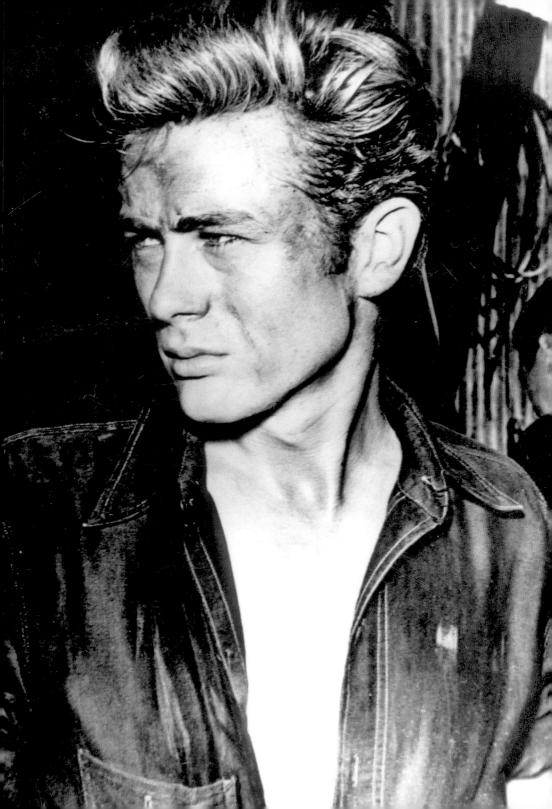

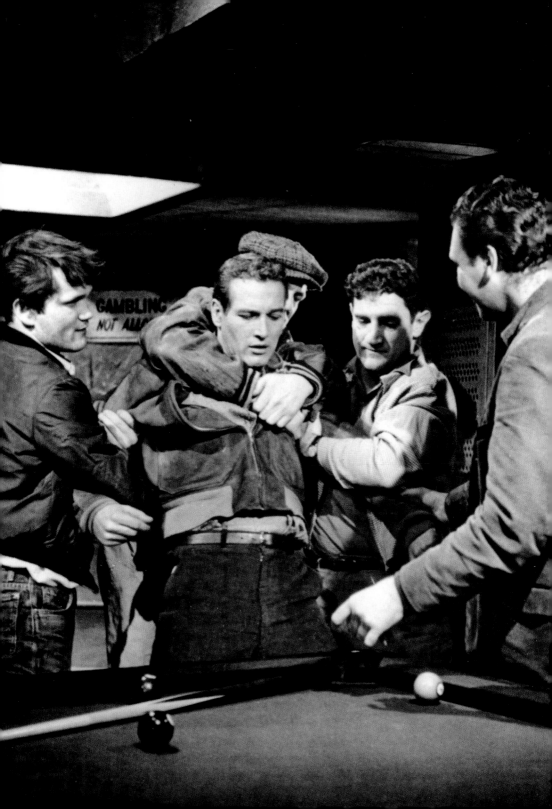

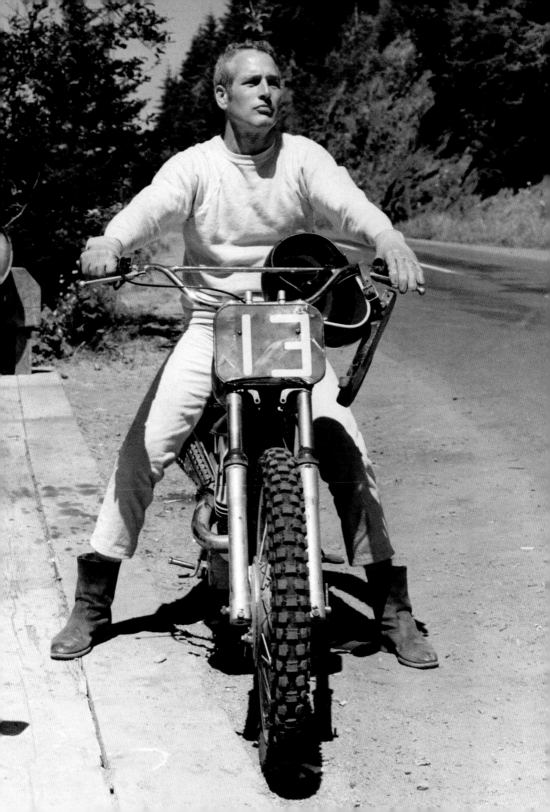

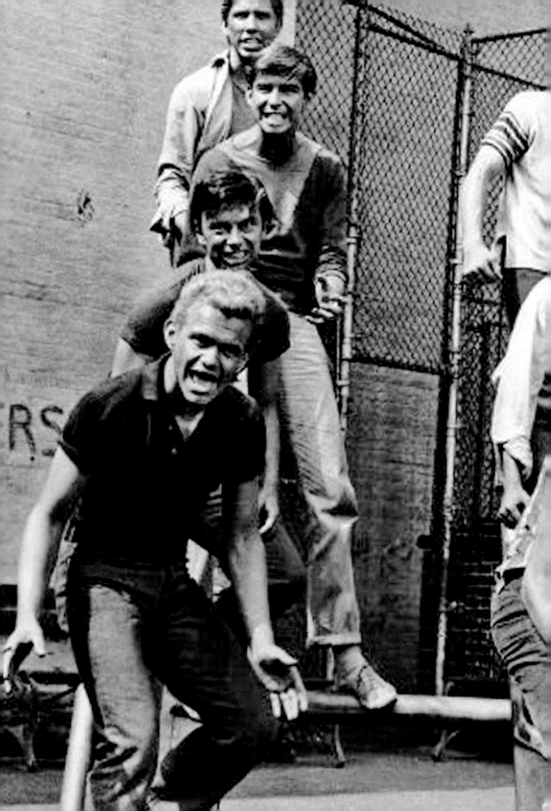

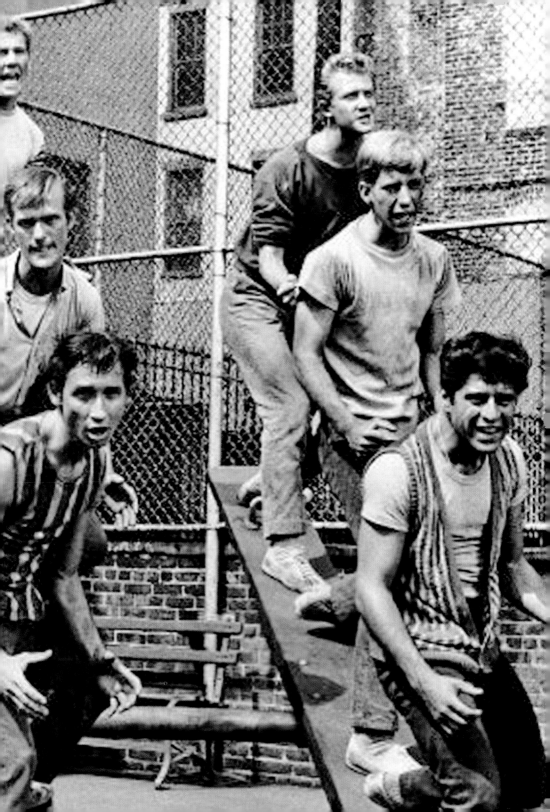

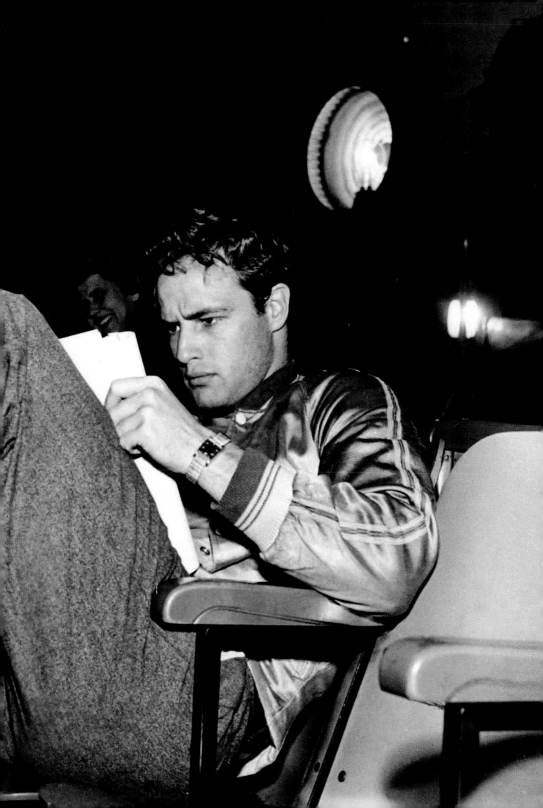

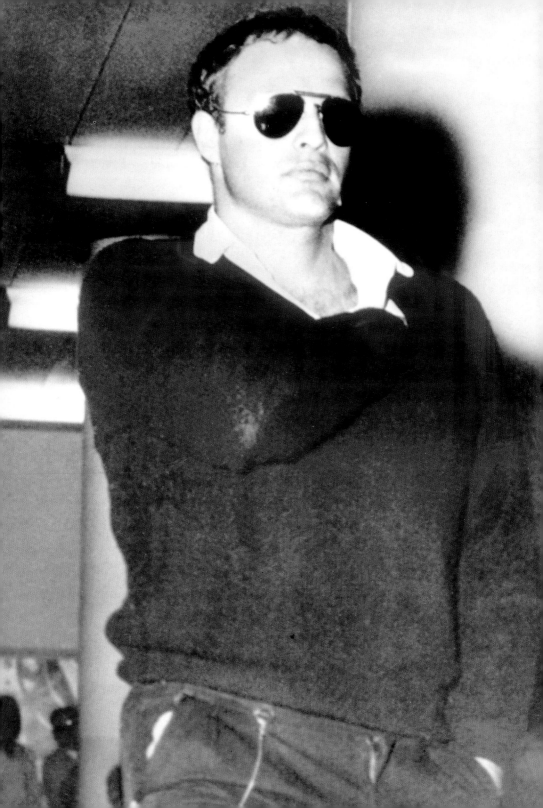

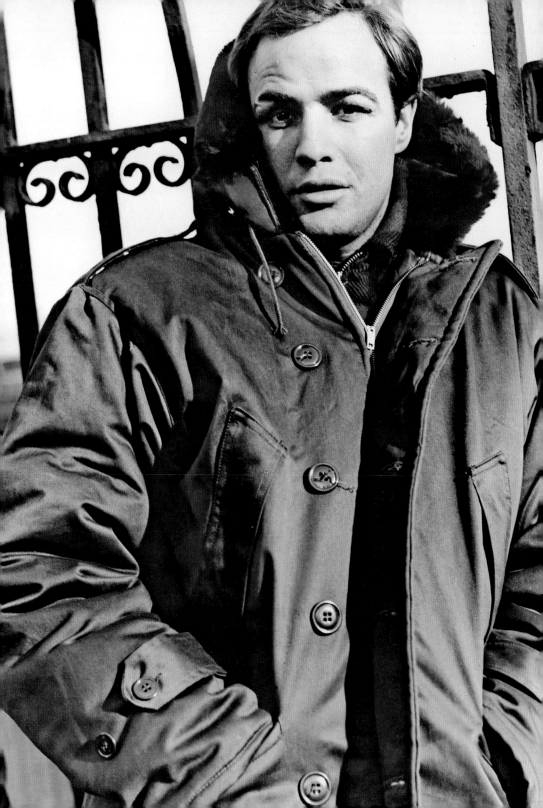

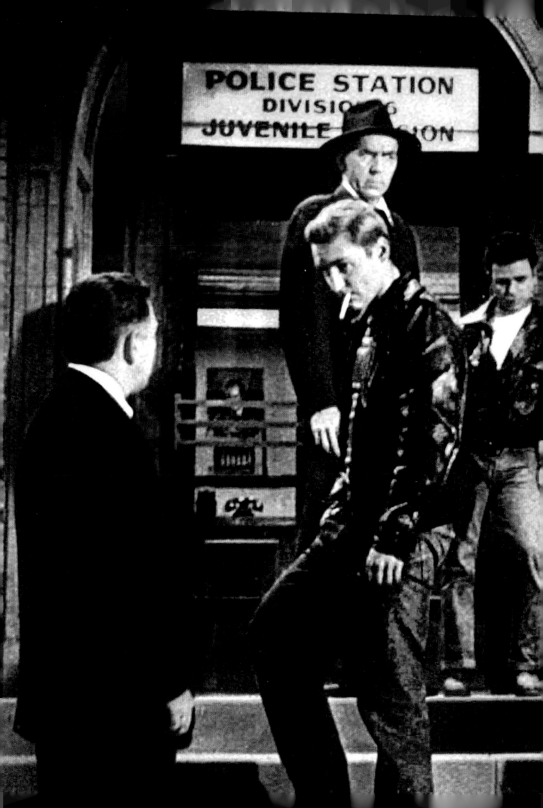

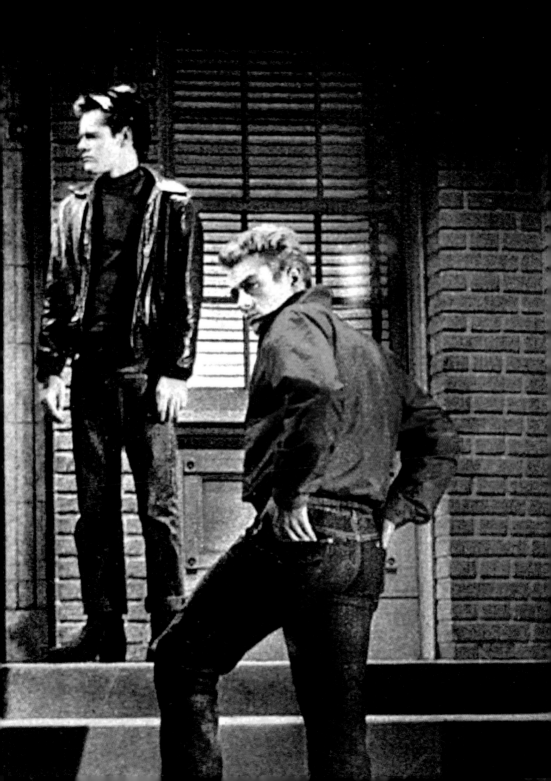

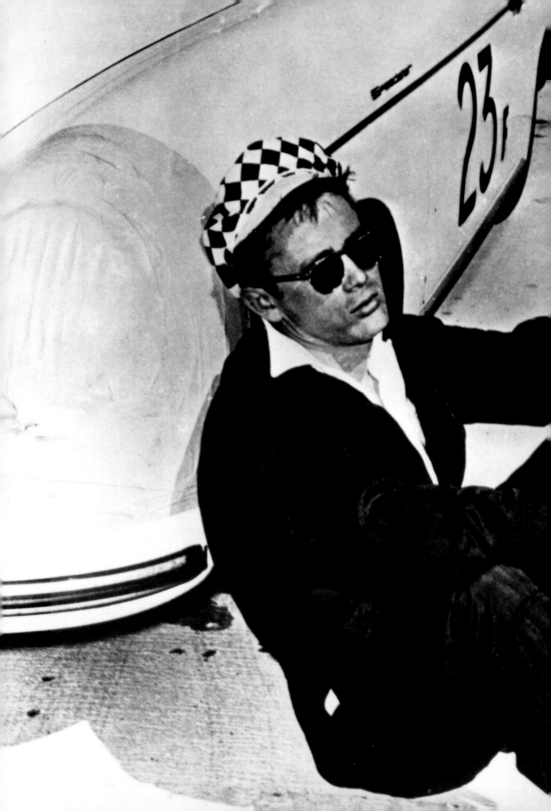

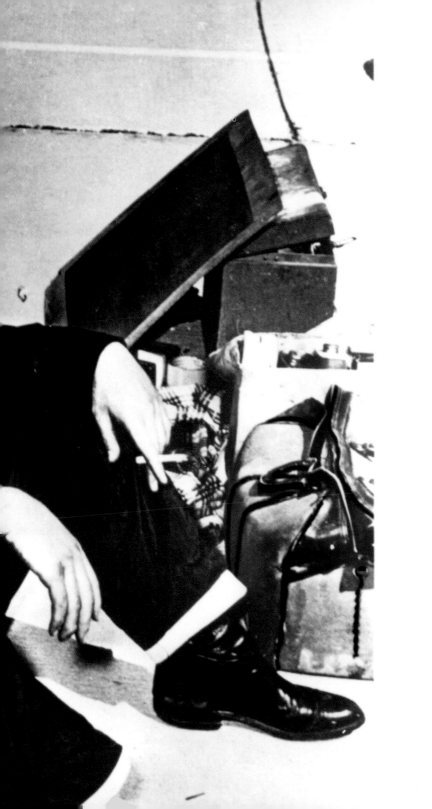

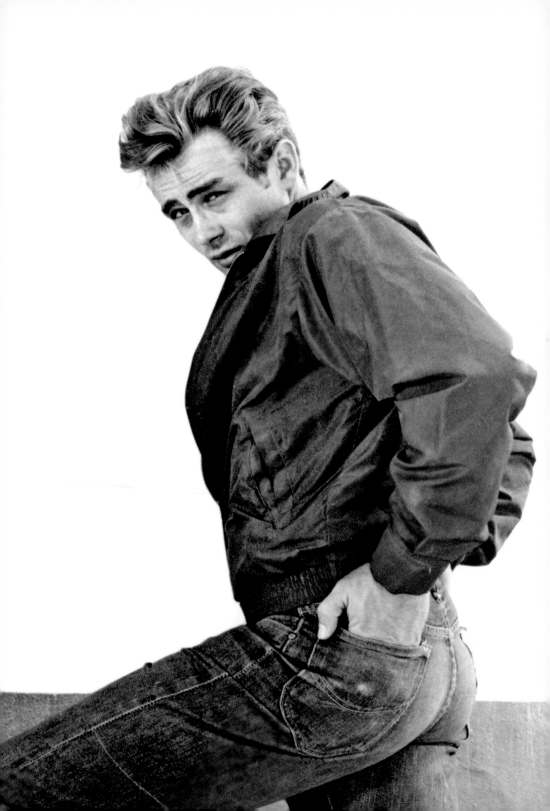

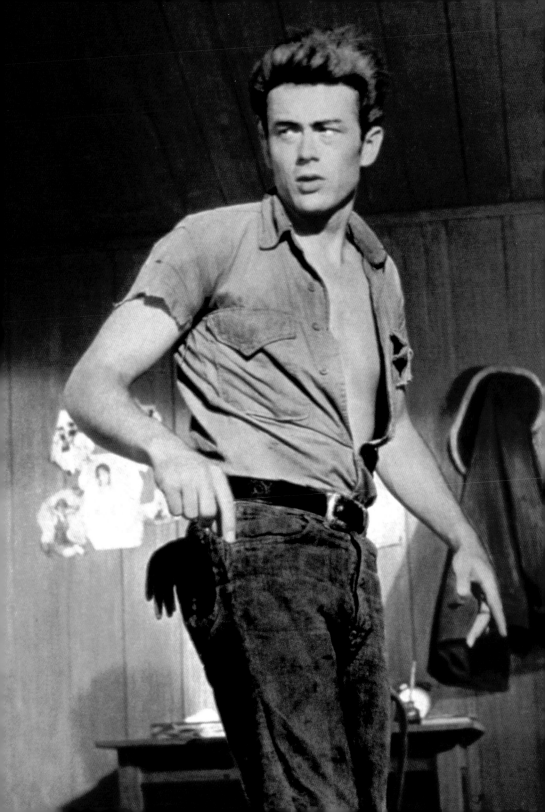

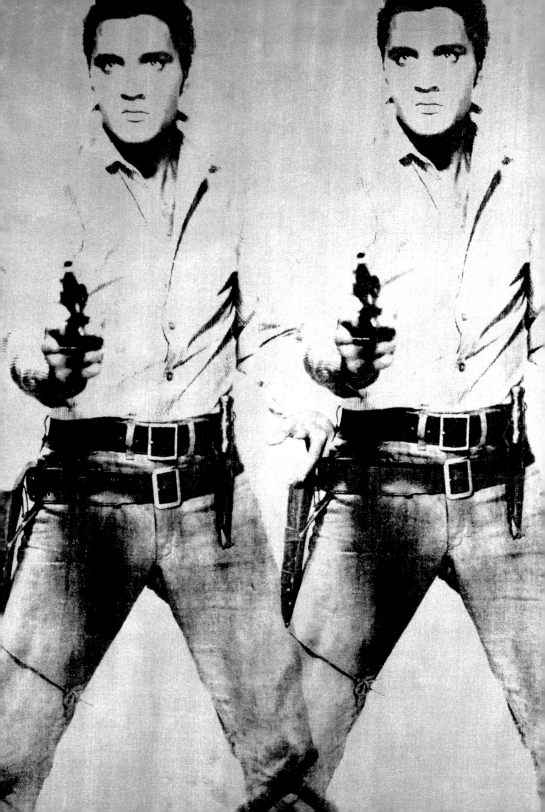

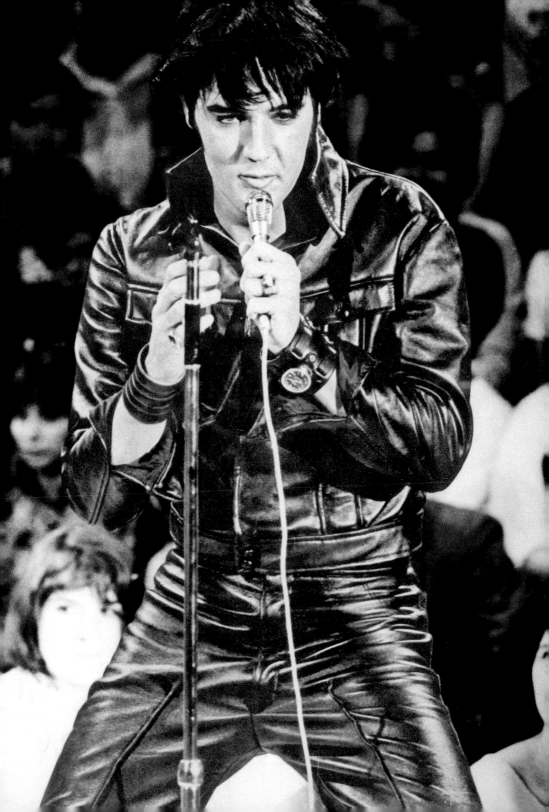

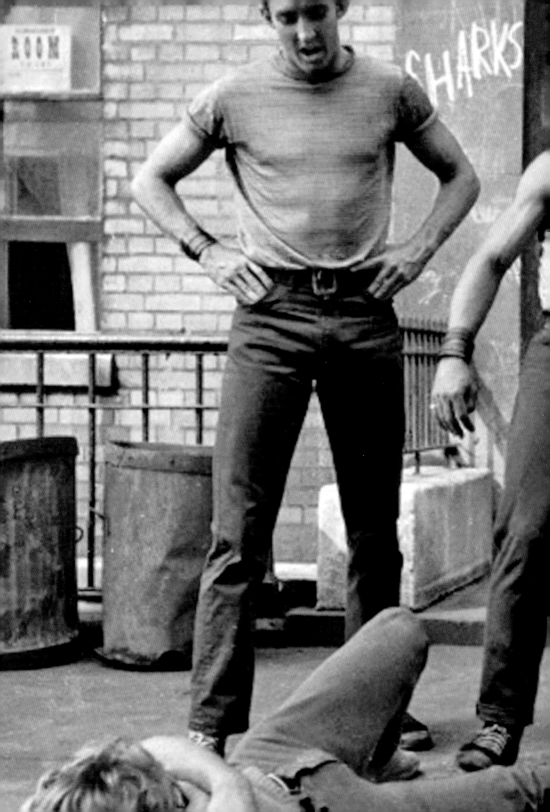

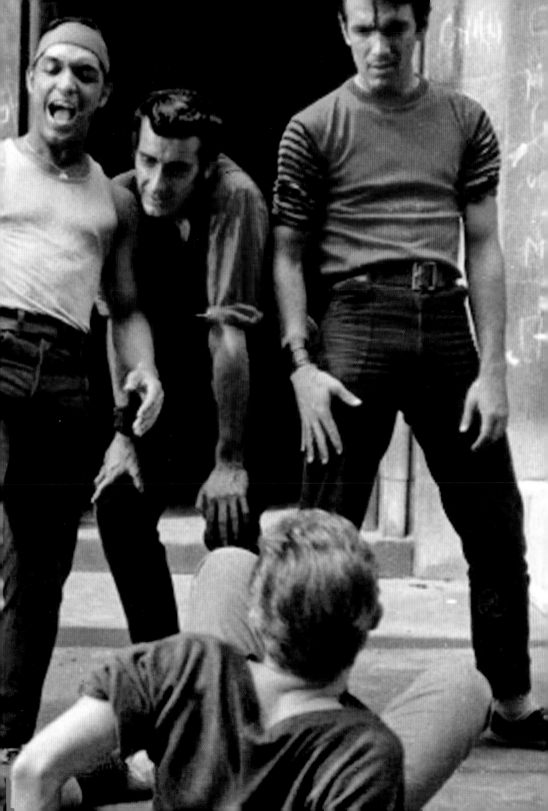

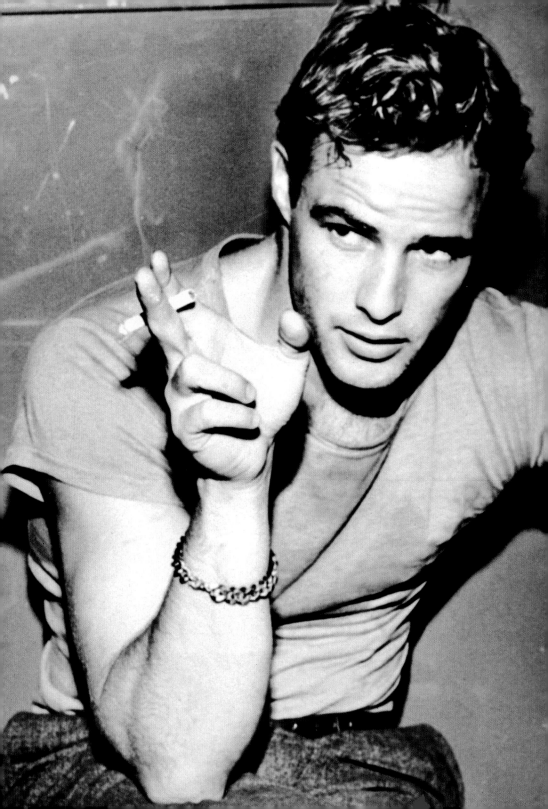

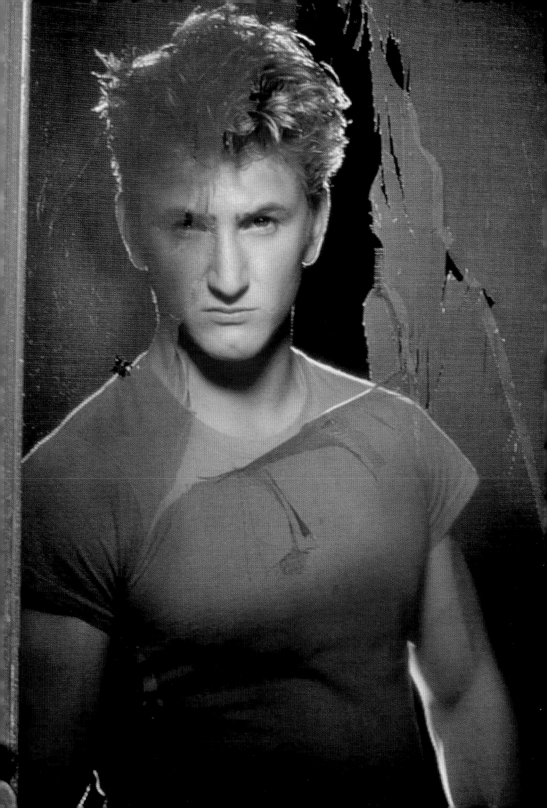

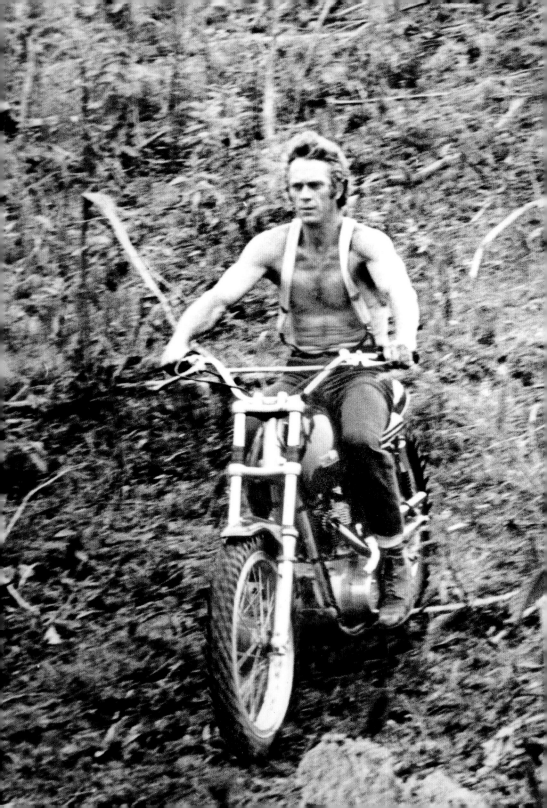

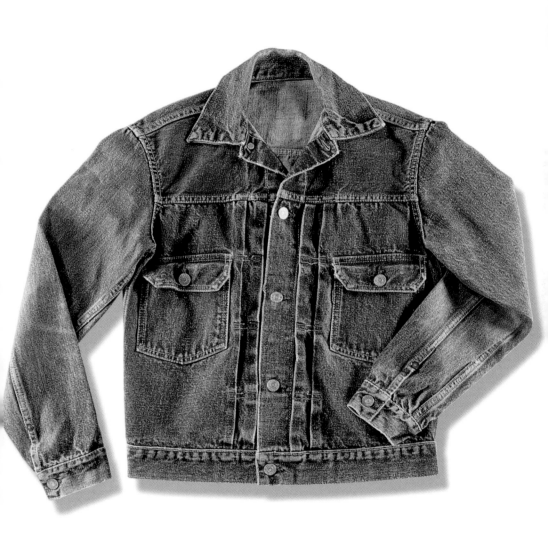

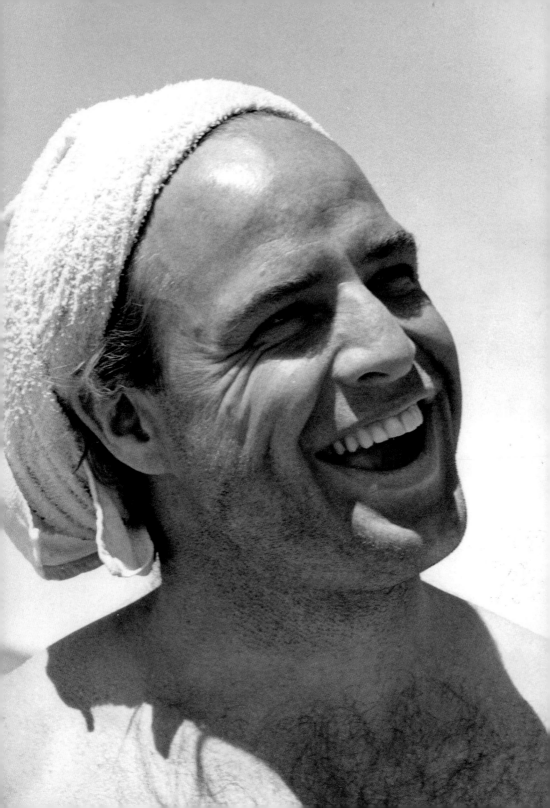

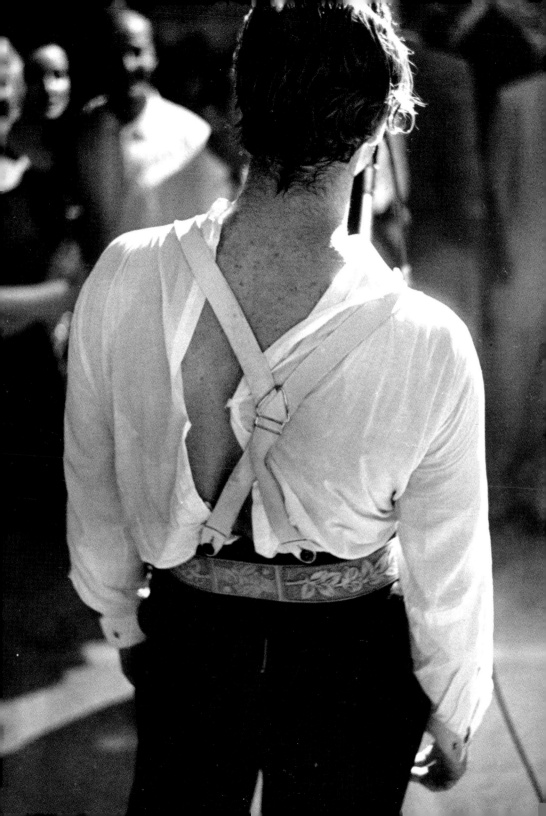

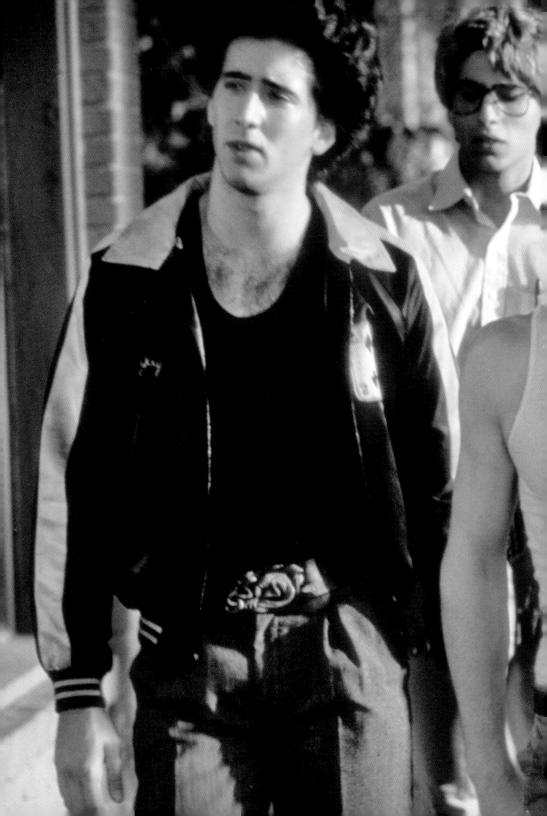

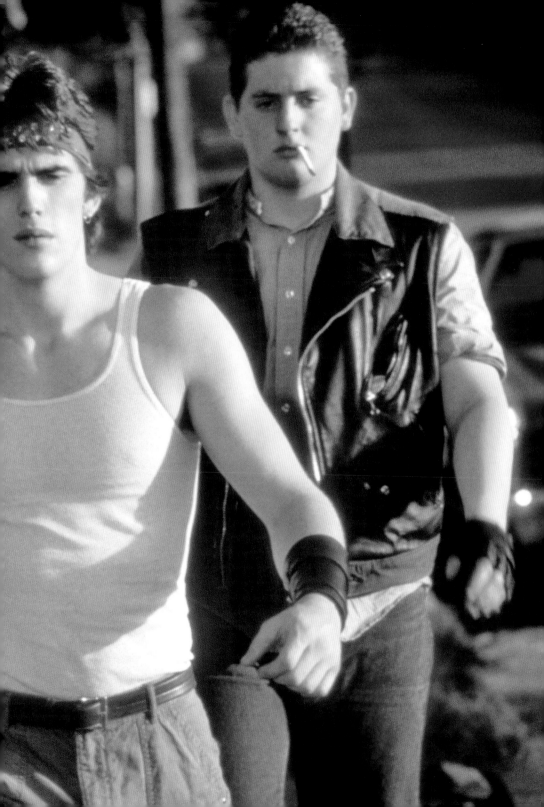

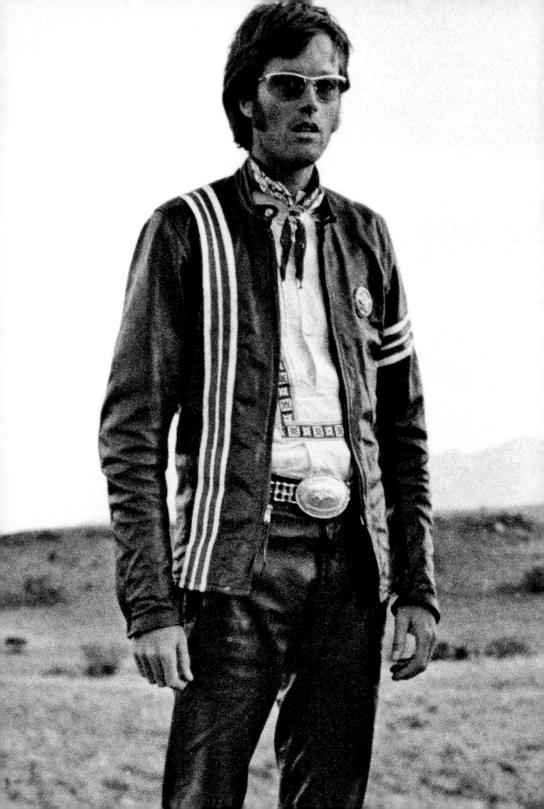

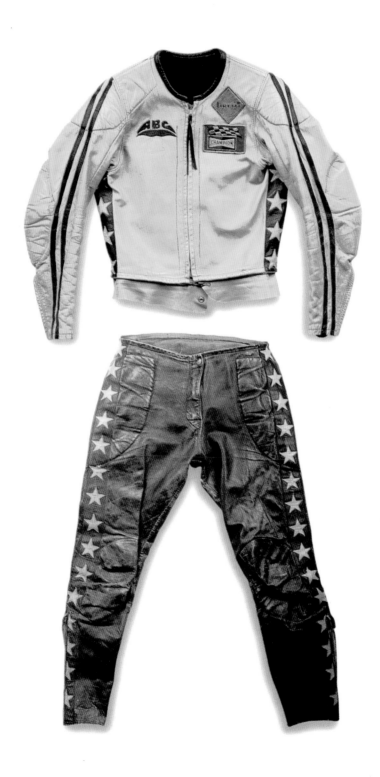

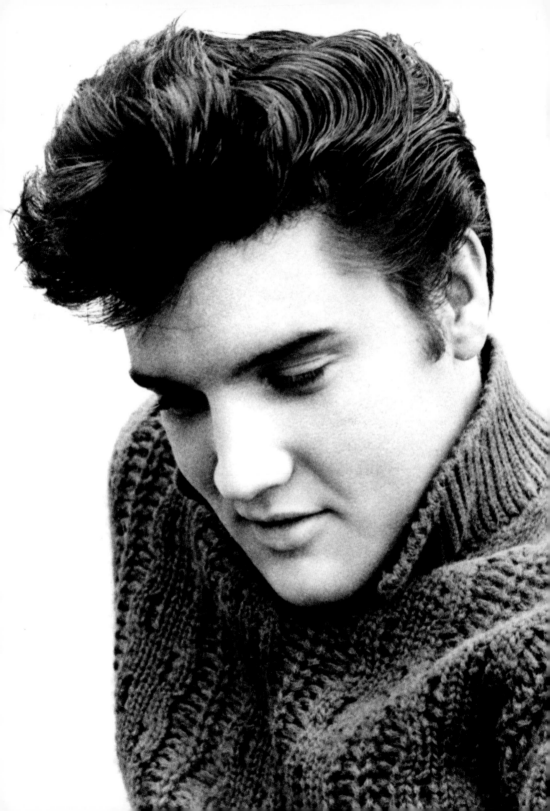

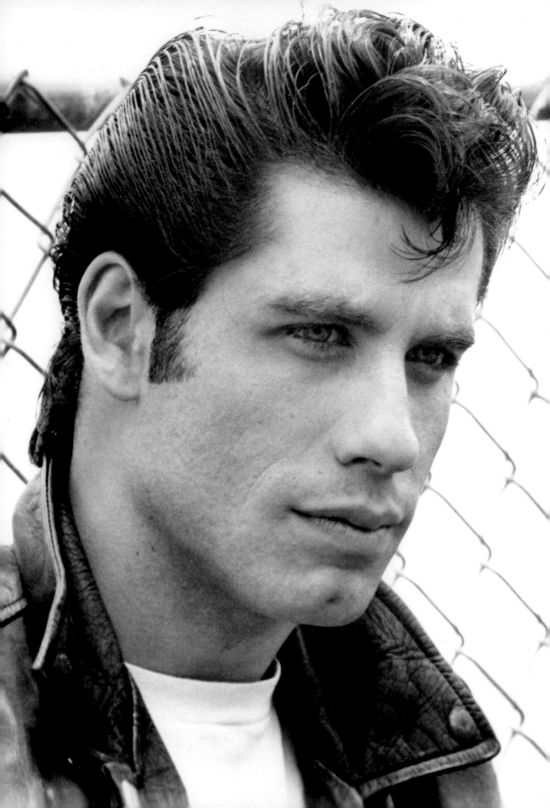

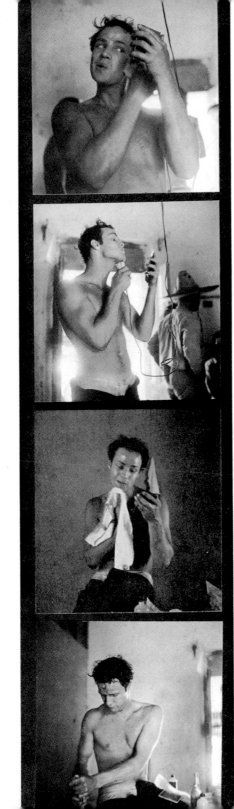

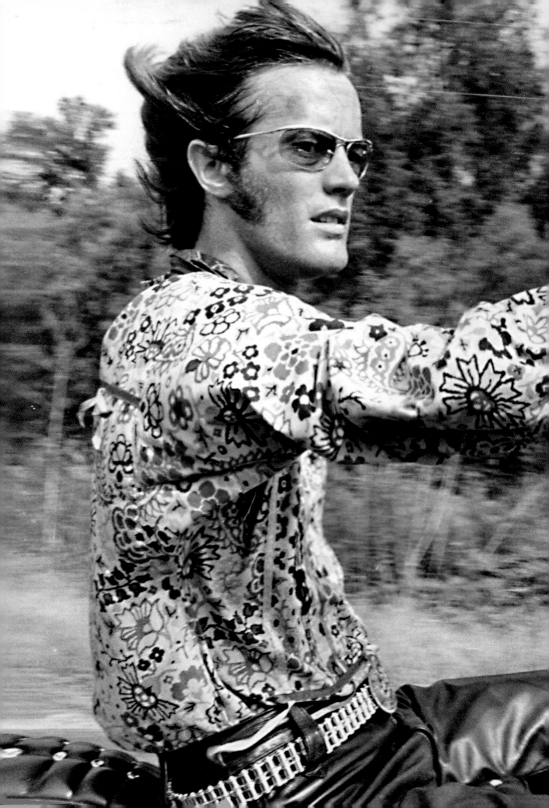

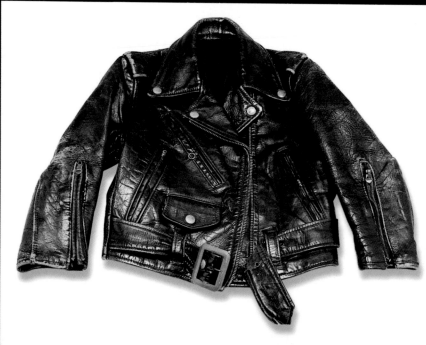

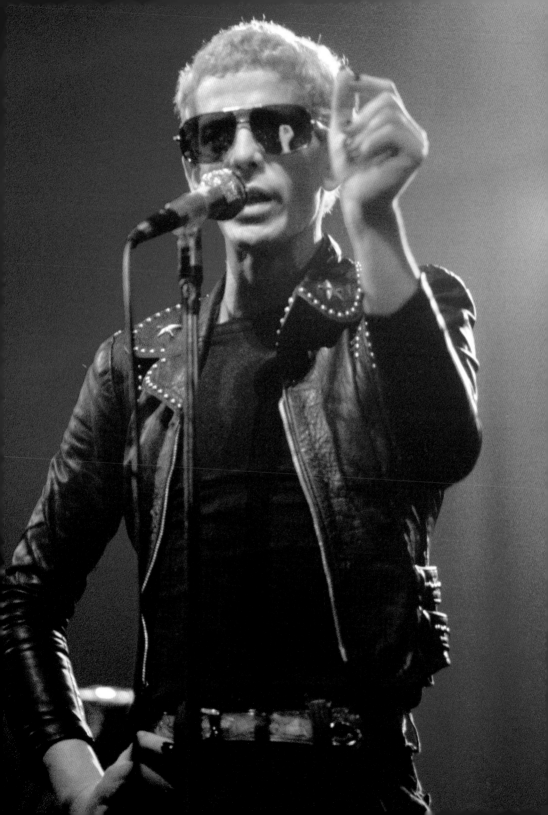

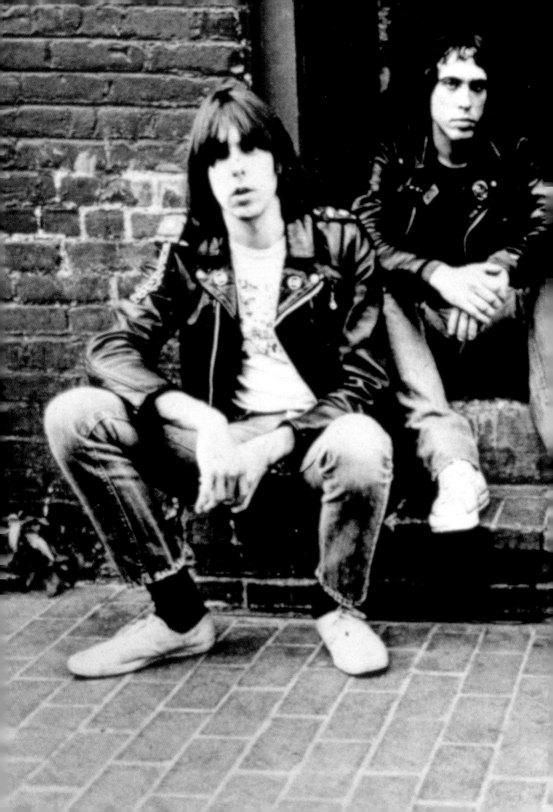

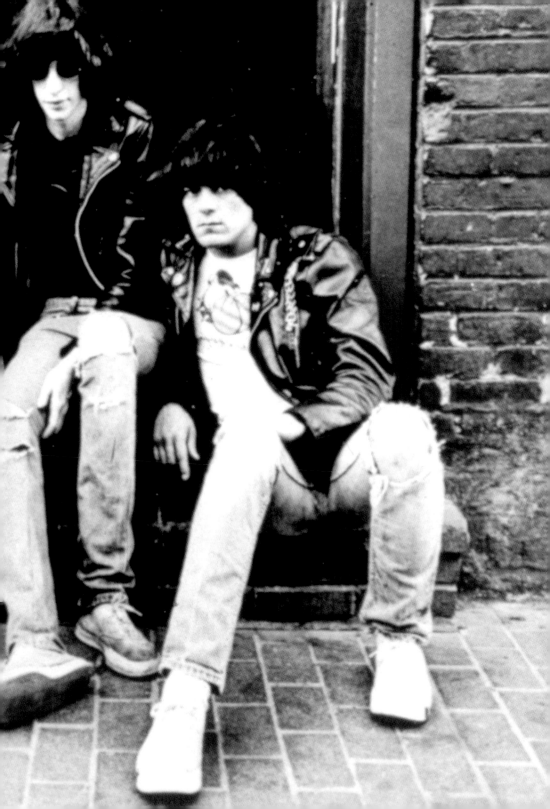

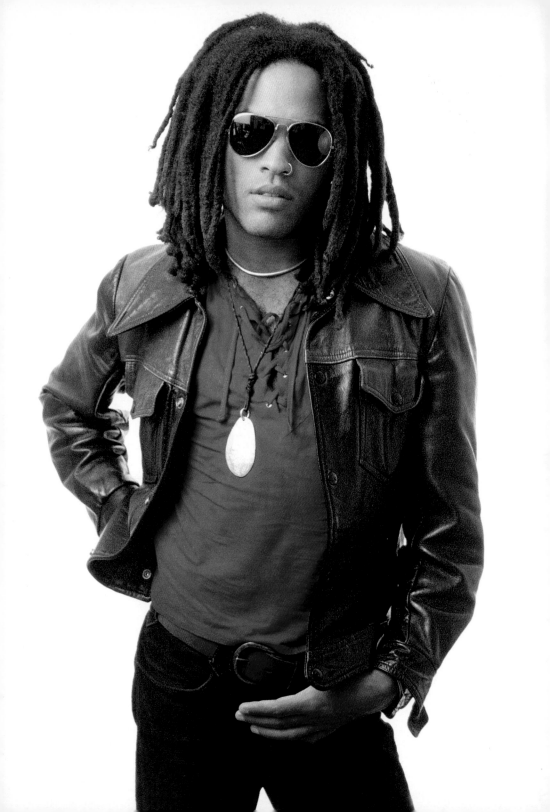

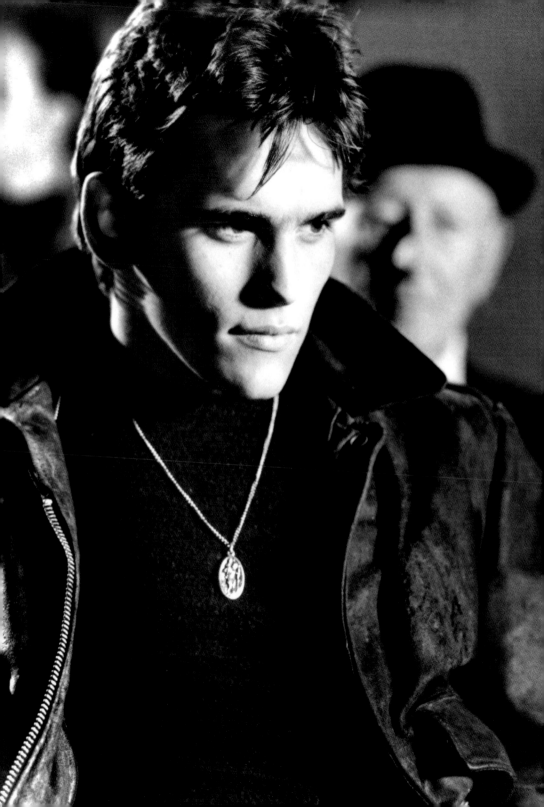

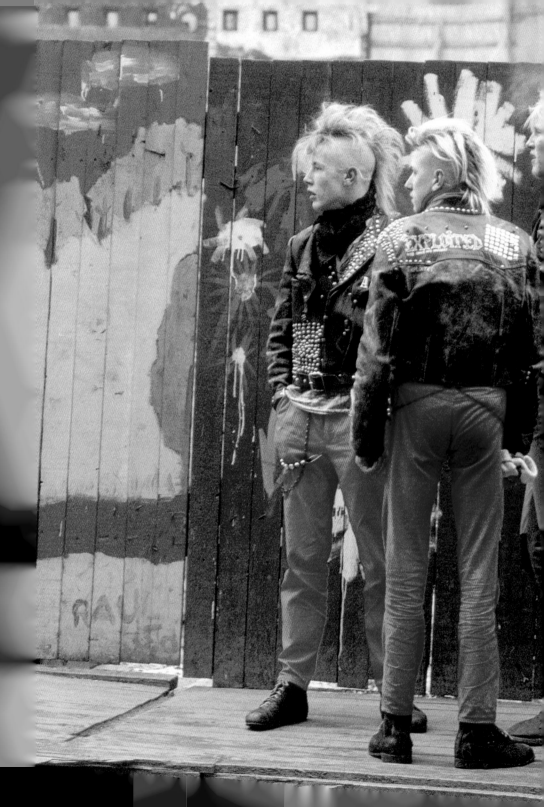

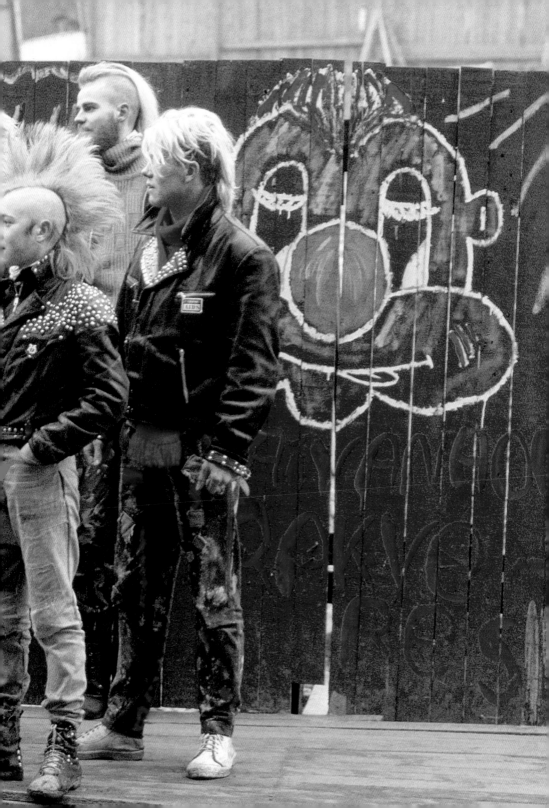

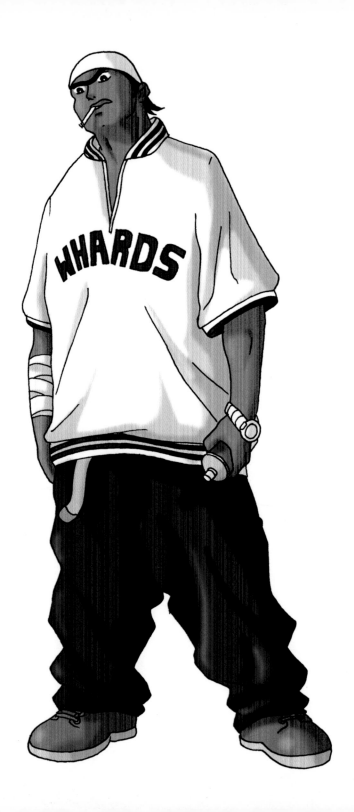

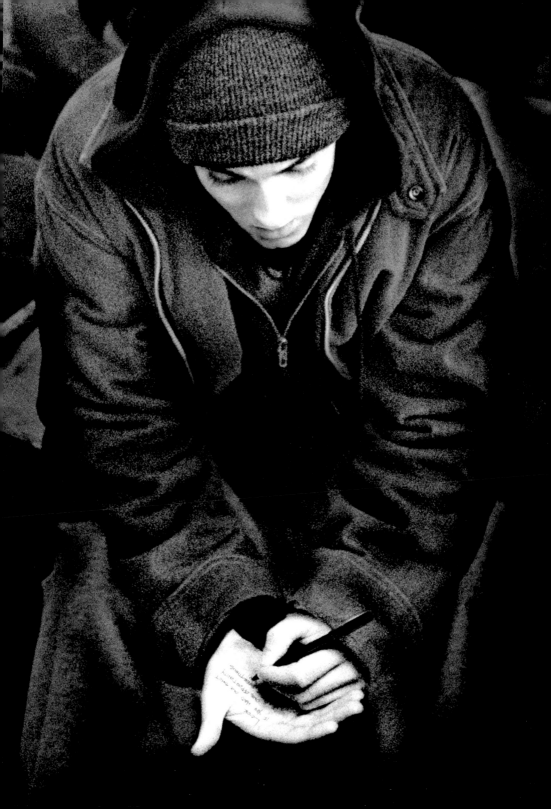

Glossary

The Actor's Studio

In the midst of the 1930s Depression, Harold Clurman, Lee Strasberg, and Cheryl Crawford founded an experimental theater company in New York called the Group Theatre. They were looking for new plays and playwrights, new acting techniques, and new actors and directors. They were particularly interested in theater that had a social conscience and was politically relevant at a time of great turmoil in the U.S. and the rest of the world. Among the directors who joined the company along the way were Elia Kazan and Robert Lewis. After the War in 1947 Clurman, Kazan, and Lewis formed a workshop group for actors. The technical approach taken was called "the Method," a procedure first formulated by Konstantin Stanislavsky, in which the actor is asked to use his memory to call up emotions needed in a scene. Lee Strasberg, a teacher and later head of the workshop, was its most famous proponent and fervent propagandist. Early members of the studio included John Garfield, Marlon Brando, Paul Newman, Maureen Stapleton, Kevin McCarthy, Shelley Winters, Montgomery Clift, Eli Wallach, Karl Malden, Julie Harris, and James Dean.

Aviators and Wayfarers

Aviator sunglasses were the choice of bikers, some of whom had been in the armed forces during World War II and the Korean conflict. Originally designed for aviators to reduce glare in the cockpit, they had metal frames and off-center, teardrop-shaped lenses. Hipsters of the period favored the Ray-Ban "Wayfarers": thick black plastic frames with a streamlined shape. Jazz musicians wore them onstage and off-. The rock musician Roy Orbison made them a badge of identity. Much later, in 1978, Wayfarers enjoyed a revival when the Blues Brothers wore them with their black suits and black fedoras.

Beat Literature

A significant development in postwar American writing, similar to the Angry Young Men movement in Britain. Beat literature was the product of a mixing of realism, existential philosophy, and often leftist political and social criticism. Both prose and poetry were characterized by a staccato stream-of-consciousness flow, harsh imagery and language, and a topical concern with stark individualism and the values of the underclass. In this the Beat style drew on the traditions of nineteenth-century naturalism. As a consequence of feeling alienated, alone, and riddled with anxiety (Darwin, Marx, Nietzsche, and Freud had removed the idea of God from intellectual thought, and Hitler seemed to do the rest), Beat writers propounded a faithless "carpe diem" attitude of individual freedom. Iconic writers of the period included Jack Kerouac, William S. Burroughs, Allen Ginsberg, Gregory Corso, and Lawrence Ferlinghetti.

Bebop

A movement within modern jazz that arose primarily in Harlem in the postwar 1940s. Its early proponents were John Birks "Dizzy" Gillespie, Charlie "Yardbird" Parker, Oscar Pettiford, Thelonious Monk, Miles Davis, Dave Tough, and other young "boppers" who ran jam sessions at Minton's Playhouse and thought of themselves as serious musicians rather than just entertainers. The music itself was as radical as the musicians who made it, and was heavily criticized at the time as having ragged, jagged rhythms, full of sudden stops and starts, fast flurries, and little regard for

melody. Duke Ellington said playing bop was like playing Scrabble with the vowels missing. Gillespie, flamboyant in his zoot suit, goatee, horn-rims, and porkpie hat, was the quintessential bopper; Charlie Parker, its genius and tragic hero.

Cool

An honorific term first used by African Americans to denote someone who could control his emotional rage in the face of abuse and adversity. It was probably derived from the idea of "being cool under fire," as opposed to being hot, blatantly emotional, and not in control, and thus giving yourself away. It is, in John Leland's perfect phrase, "the displacement of rage" by an attitude of total non-engagement. The term was taken up and disseminated in the 1940s and 1950s first by jazz musicians, then by Beat poets and their following. "Cool" was the ultimate word for the counterculture and, as such, was eventually co-opted by the mainstream and became a lackluster, all-purpose synonym for "good."

DA Hairstyle

DA was an acronym for "duck's ass," which perfectly describes this hairstyle popular with working-class youth in the 1950s. The hair was worn long, perhaps five inches or more on the top, sides, and back, combed high over the forehead, and straight back along the sides to meet dead center in the back, the way a duck's wings would come together. The DA was accentuated by the hair in back being cut straight across the nape of the neck, rather than tapered. The look was fully achieved with a good deal of thick hair cream (jokingly called "grease," no matter what the brand). After Elvis Presley first appeared on TV in the summer of 1955, wearing sideburns with his DA, that affectation was incorporated into the style.

Engineer Boots

Often thought of as having originally been designed for motorcyclists, engineer boots were first made for railroad engineers. They were often heavily cleated, and the true ones had heels with concave sides. The calf-high, straight-sided boots were made of durable, thick black cowhide, with a strap-and-metal buckle over the instep; a pattern of large metal studs often adorned the boot.

Greenwich Village

In the 1950s a number of urban groups—African Americans, Jewish intellectuals, jazz musicians, actors, and artists living outside the mainstream—gravitated to places such as New York's Greenwich Village, where radical ideas and literature, new jazz, drugs, and sexual freedom merged. The Village itself became, to quote John Leland, a "Bohemian-literary-artistic-underground-mafioso-pinko-revolutionary-subversive-intellectual-existential-anti-bourgeois café." In other words, it nurtured and fostered everything Levittown was against.

Hip

Another term that probably originated with urban African Americans who were forced to construct new identities for themselves in the face of a transient, uprooted existence; "hip" is the cultivated taste of the disenfranchised. It represents the enlightenment of the counterculture, which holds itself above and apart from popular bourgeois culture.

Ivy League

The phrase used most often during the period to describe the elite style of the Eastern Establishment. Specifically, it refers to those schools that traditionally prepare young men and women for responsible and powerful roles in society. The clothing they wear symbolizes the status of conservative power and position. Richard Martin and Harold Koda quote social critic John Sedgwick on the subject: "The Ivy Leaguer 'is really buying an ethic' in his clothing choices. The ethic is a Puritanical anti-fashion conviction that classic garments should continue in the contemporary wardrobe like a college's well-established and unquestioned curriculum" (p. 138).

Jeans

In the 1950s, there were only three brands of blue jeans. The best known were made by Levi Strauss & Co.: fourteen-ounce indigo-dyed cotton twill with two front J-shaped pockets, one with a change pocket, and two rear pockets with a curved V-design, all copper riveted at the stress points; a metal-shank button fly; and cotton selvage under the outseam, all double- and triple-stitched in heavy orange thread. The cut was trim, with a short front rise and a higher rear rise. They were built for rugged swaggering. The other brands, Wrangler and Lee, were popular alternatives, more favored with rural cowboys than cyclists.

Jivey Ivy

An exaggerated version of the Ivy League style worn by jazz musicians and hipsters. It typically consisted of a short, close-fitting, four-button, natural-shouldered mohair suit, with "drainpipe" trousers that barely covered the ankles, narrow Chelsea boots with Cuban heels, a "highboy" button-down shirt, and a narrow two-inch wide tie. The coolest members of the fraternity—such performers as Bobby Darin and the Modern Jazz Quartet—buttoned only the top button of the jacket and accompanied the outfit with a small-brimmed fedora.

Neo-realism

A cinematic movement of gritty social concerns that began in Italy after the Second World War and was taken up by other countries thereafter. The main Italian proponents and creators were directors Luchino Visconti, Roberto Rossellini, Vittorio De Sica, and Michelangelo Antonioni. Much of the inventiveness in these films was a necessity of the postwar economy. Location shots, for example, were often used because there was not enough money for soundstages and scenery, which gave the films a documentary-like, gritty quality. Street people and natural lighting produced a naturalistic, grainy aura to these films, of which Rossellini's *Open City* (1945) is often said to be the first in the genre. The Italian cinema was a great influence on the new seriousness of American films in the late 1940s and early 1950s. Directors such as Elia Kazan, Nicholas Ray, and Robert Wise, and actors like Montgomery Clift were serious students of the form.

Pegged Pants

To accompany the wide-shouldered, mid-thigh-length jacket of the zoot suit, there were "pegged pants": high on the hips, the trousers cut super-full with about thirty inches in the knee and then tapered down to fourteen inches in the cuff. Some of the hippest cats had zippers sewn into the bottom inseams to make the trousers easier to take on and off. In the 1950s, the trousers often had a strip of contrasting color running down the outseam of each leg as a focal point of interest.

Prole

Short for proletariat, the class of industrial and other blue-collar workers who have nothing to sell but their labor. As such, the adjective indicates a social, political, and economic category. As the term relates to style and clothing, there are a variety of garments worn by blue-collar workers (the blue work shirt, for example) that have iconic interest because they have been used to express rebellion against the dominant middle-class culture. It almost goes without saying that in the recent past designers have turned virtually all of these items into chic, upscale leisure wear.

Schott Leather Jacket

The iconic black leather jacket, like its brown GI version, was made by Irving Schott, who introduced the zipper closure in 1925. The type worn by Brando in *The Wild One* was the Schott company's "Perfecto" model, with a slightly off-center front zipper, two chest zippers, sleeve zippers, and a belted waist, all to protect the cyclist from wind, wet, and being skinned alive in hazardous "slide-outs."

T-shirt

Originally, both the T-shirt (shaped like a *T*) and the undershirt (which had shoulder straps instead of sleeves) were meant to be worn under a dress or sports shirt or a sweater. But hardworking laborers saved their shirts for Saturday nights and Sunday mornings, and their sons—the "greasers" with the DA haircuts—wore them tight, and rolled a pack of cigarettes in the sleeve. Occasionally, the rolled-up sleeve revealed a tattoo, a symbol perhaps of a gang affiliation. Black or white were the only color alternatives, without logos or messages.

Zoot Suit

No one has described the zoot suit's exuberance better than Malcolm X in his autobiography:

> *"I was measured, and the young salesman picked off the rack a zoot suit that was just wild: sky-blue pants thirty inches in the knee and angle-narrowed down to twelve inches at the bottom, and a coat that pinched my waist and flared out below my knees."*
>
> —*Malcolm X*, p. 53

Malcolm X put on his first zoot suit when he was fifteen, in 1940s Boston. By then it was already a powerful symbol of juvenile delinquency and terminal coolness. Three years later—on June 3, 4, and 5, 1943—in Los Angeles, the infamous Zoot Suit Riots occurred, in which hundreds of young Mexican American men wearing the drape outfit were beaten and stripped by U.S. servicemen in a rampage of racial brutality. Afterwards, zoot suits were banned in Los Angeles, but they were still worn in many other urban landscapes until the mid-1950s.

The basic model was built of colorful gabardine (electric blue, salmon pink, coral, dove gray, rust red, maroon, powder blue, and cherry pink were all highly-prized shades). The coat was exaggeratedly wide in the shoulders, narrow in the waist, and long in the body; the front had long, rolling lapels that met in a single button slightly below the navel. Trousers were high-waisted, sitting several inches above the natural waist, very full in the thigh and knee, and sharply tapered at the cuff.

To accessorize this "drape shape with the reet pleat," the hipster wore a "Mr. B" rolled shirt collar (named after Billy Eckstein, the jazz singer and bandleader who popularized the style), a thin tie, a long, dangling jewelry chain, and a wide-brimmed porkpie hat.

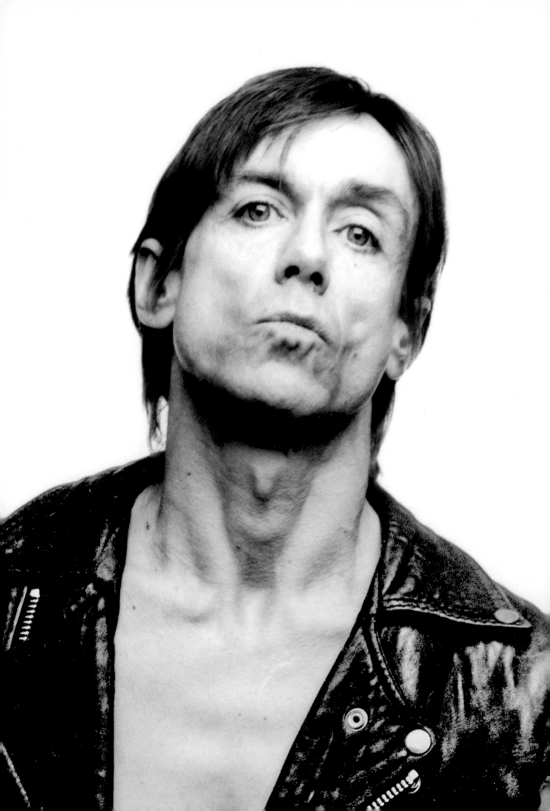

Chronology

1920: Edward Montgomery Clift is born on October 17, in Omaha, Nebraska. Marlon Brando is born on April 3, also in Omaha.

1925: Paul Newman is born on January 26, in Cleveland, Ohio.

1931: James Dean is born on February 8, in Marion, Indiana.

1935: Elvis Presley is born on January 8, in Tupelo, Mississippi.
In January, Montgomery Clift appears on Broadway for the first time, in *Fly Away Home*.

1943: Brando moves to New York City, drifts into the vibrant Greenwich Village scene, and enrolls in the Dramatic Workshop of the New School for Social Research. He studies with famed acting teacher Stella Adler and plays roles in Workshop productions of Shaw, Shakespeare, and John Millington Synge.

1944: On October 19, Brando appears on Broadway for the first time, in John Van Druten's *I Remember Mama*.

1946: Harold Clurman produces Maxwell Anderson's *Truckline Café*, with Elia Kazan as director. They cast Brando in a major role. This experimental work of dramatic naturalism is reviled by the critics and closes after one week, but Brando is noticed for his realistic, invigorating performance.

1947: The Actor's Studio is formed, with classes taught by Bobby Lewis and Elia Kazan. In addition to Brando, students include Julie Harris, Montgomery Clift, Eli Wallach, Paul Newman, Karl Maldon, and Maureen Stapleton.
Professor Alfred Kinsey publishes *Sexual Behavior in the Human Male*. In weeks the book becomes a best seller. It is followed in 1953 by *Sexual Behavior in the Human Female*, which also becomes a best seller.
In September, Elia Kazan and Tennessee Williams cast Brando in the lead role of Stanley Kowalski in Williams's new drama *A Streetcar Named Desire*. The play opens on Broadway on December 3, and Brando is hailed as the new lion of the theater.

1948: Montgomery Clift's first film, *Red River*, starring John Wayne is released.

1949: Brando signs on to do his first film in Hollywood, *The Men*, about paraplegics in a veteran's hospital. He reprises his role of Stanley Kowalski in a film version of *A Streetcar Named Desire*, directed again by Kazan, and costarring Vivian Leigh as Blanche Dubois.
On March 25, James Dean makes his first public appearance on television, in "Hill Number One," on the show *Family Theatre*.
On December 3, Dean makes his first appearance on Broadway, in *See the Jaguar*.

1951: *A Place in the Sun* is released, starring Montgomery Clift and Elizabeth Taylor. They are hailed as the world's most beautiful couple, and Clift becomes a star.

Punk rocker Iggy Pop first gained fame in the 1960s as the lead singer of The Stooges.
Pop kept the denim jeans and leather jackets of the earlier rebels but lost the shirt. © *Rue des Archives.*

1952: In November, editions of *The Paris Review* and *New World Writing* jointly publish the first two sections of Jack Kerouac's *On the Road*. The novel, which will become the most famous in Beat literature, is published in full by Viking Press in 1957.

1953: Paul Newman makes his Broadway debut in *Picnic*.
Brando adds to his screen persona of raw prole hero with *The Wild One*. His portrayal of Johnny, the motorcycle-riding hipster, strikes a resonant cord with the young audience and raises Brando to star status.
In September, Hugh Hefner begins publication of *Playboy*, a monthly magazine of sexual content. Sales reach 100,000 copies within a year.

1954: On July 5, a young man named Elvis Presley walks into Sam Phillips's small recording studio in Memphis, Tennessee, to make a demonstration record. He records a blues song, "That's All Right, Mama."
On July 28, *On the Waterfront* is released, with an incredible cast of Method actors that includes Karl Malden, Rod Steiger, Eva Marie Saint, and Lee J. Cobb. It is soon considered one of the most important American films ever made. In the role of Terry Malloy, Brando reaches the zenith of his career as an actor.

1955: In the summer, Elvis Presley appears on TV for the first time, in a music variety program called *Stage Show*. Within a year, he will appear on the popular *Ed Sullivan Show* and cause an earthquake of concern among middle-class parents.
In March, *East of Eden*, James Dean's first film, is released, directed by Elia Kazan.
On September 30, James Dean is killed in an auto accident on Route 41 in Paso Robles, California.
On October 13, Allen Ginsberg gives his first public reading of *Howl* in a converted garage in San Francisco. The poem had just been published there by Lawrence Ferlinghetti's City Lights Press. It becomes the most famous poetic statement of the Beat generation.
In October, *Rebel Without a Cause* is released, directed by Nicholas Ray.

1956: In July, *Somebody Up There Likes Me* is released; a film biography of boxer Rocky Graziano, it stars Paul Newman. The part was originally planned for James Dean who was killed before filming began.
In October, Dean's last film, *Giant*, is released.
In November, *Love Me Tender*, Elvis's first movie, is released.

1958: Brando and Clift, along with Dean Martin, star in *The Young Lions*.
Paul Newman stars in *Cat on a Hot Tin Roof*.

1961: In a neorealist film that seems to end the 1950s more than start the 1960s, Newman stars in *The Hustler*. It is the end of an era.

Sylvester Stallone and Henry Winkler in The Lords of Flatbush *(1974), a generic teenage rumble movie. Its prototype was Maxwell Shane's* City Across the River *(1949), the film based on Irving Shulman's novel* The Amboy Dukes *(1945). © Rue des Archives.*

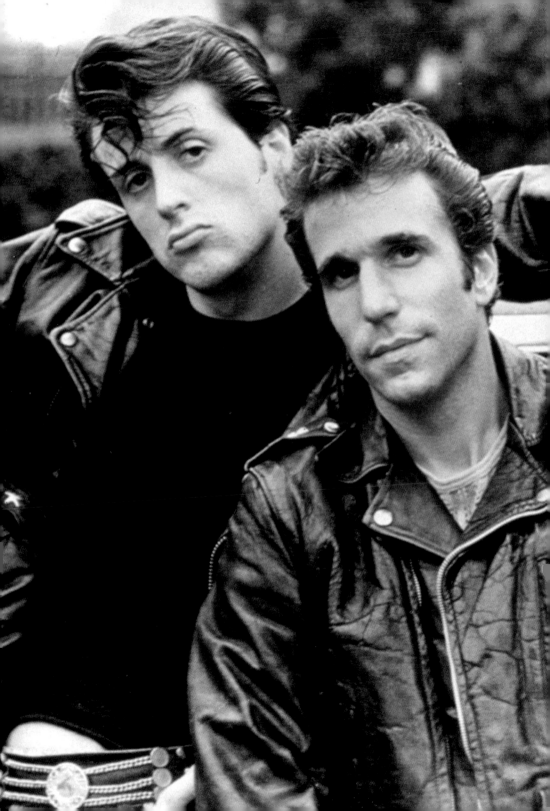

Rebel Style

The knight in full battle armor, ready to tilt with any and all bourgeois threats that may come his way. © The Kobal Collection.

By the 1950s, the T-shirt was established as an outer-garment sports shirt. Though jeans were first popularized in the U.S. in the 1850s, they were infamously paired with the T-shirt in the 1950s to create the classic rebel uniform. © (top) Fruit of the Loom, Londres. © (bottom) Getty-images.

The 1950s *Rebel Without a Cause* poster says it all: switchblade rumbles, young love, jeans, and T-shirts. © The Kobal Collection.

James Dean as an oil-soaked Jet Rink surveying the Texas landscape in *Giant* (1956), his last film. Although the early parts of the film are set in the 1920s, Dean's hairstyle is straight out of the 1950s rebel days. © Collection Christophe L.

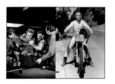

Paul Newman, the last rebel without a cause, in *The Hustler* (1961). Like Brando, it was Newman's ability to convey brooding sensuality that made him a prole hero. © Collection Christophe L.

A slightly more cleaned-up rebel out for a Sunday drive, with dirt bike (instead of a Harley hog), light-colored jeans, sweatshirt (instead of leather), and suede boots. © Collection Christophe L.

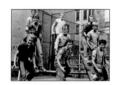

Director Robert Wise originally hoped Presley would fill the jeans of *West Side Story*'s gang leader Tony Mordente but Presley's manager wasn't interested. © The Kobal Collection.

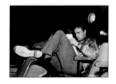

Marlon Brando in his pre-film years in the theater, studying a script. The unkempt hair and nylon baseball jacket worn with casual trousers mark him as an iconoclast. © The Kobal Collection.

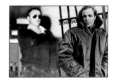

While most film stars were sure to be well groomed before being seen in public, Brando didn't seem to care. Authenticity was part of his allure. © Photofest.

Brando wearing the definitive prole gear: army surplus G.I. hooded parka, as sold in Army & Navy stores across the country in the 1950s and 1960s. © Getty-images.

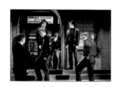

Confrontation scene in *Rebel Without a Cause* (1955). They all wear jeans and engineer boots, but Dean stands apart from the lower-class characters in his more middle-class red nylon Windbreaker. © Rue des Archives.

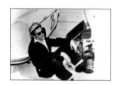

A laconic James Dean, wearing the typically cool Wayfarer sunglasses and jeans, but accompanied by a raffishly hip souvenir-racing cap. © Akg-images.

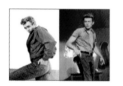

Here, Dean sports a 1950s-styled haircut, Lee Rider jeans, a waist-length nylon Windbreaker, and a cynical sneer. © The Kobal Collection.
An action shot from *Giant* (1956). Although the trappings are here—the jeans, garrison belt, and open work shirt—the film showed none of the brooding sense of alienation Dean was capable of conveying. © Collection Christophe L.

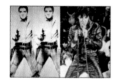

The famous Andy Warhol silk screen artwork of Elvis Presley as a Hollywood cowboy. © Andy Warhol Foundation/Corbis.
Presley at mid-career, during his resurgent 1968 TV special. The high-stand collar became something of a trademark detail of his costumes. © Corbis.

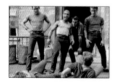

The Sharks and Jets rumble in Robert Wise's *West Side Story* (1961), a musical about juvenile delinquency, set in the tenements of Manhattan's Upper West Side barrio. © The Kobal Collection.

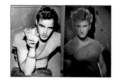

A tousled Brando, wearing the iconic garment he had made famous in *A Streetcar Named Desire* on the stage in 1947. © Getty-images.
Sean Penn, the spiritual son of Brando and third generation of rebel actors, doing his best imitation of his idol, wearing the de rigueur T-shirt. © Rue des Archives.

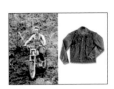

Steve McQueen as Boon Hogganbeck in Mark Rydell's *The Reivers* (1969). McQueen didn't just play a rebel, he was one. © Rue des Archives.
A model of form and function, this original ranch jacket is an example of the genius of American design: unadorned, pure heavyweight denim, with metal buttons, two chest pockets, waist side-adjustment tabs, button cuffs, and yokes back and front. © LS & Co. Archives.

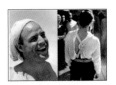

Brando relaxing on the set, when he was still incredibly handsome, trim, and charismatic. Probably from the *One-Eyed Jacks* period of the early 1960s. © Sam Shaw/Roger-Viollet.
"The world's most exciting actor," still in costume at a good-bye party on the set of *One-Eyed Jacks* (1961), the only film Brando ever directed. © Sam Shaw/Roger-Viollet.

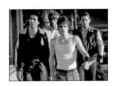

Nicolas Cage, Vincent Spano, Matt Dillon, and Chris Penn in Francis Ford Coppola's *Rumble Fish* (1983), a film that centered around the exploits of rebel youth. © Photofest.

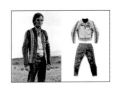

Peter Fonda as Captain America in *Easy Rider* (1969). He wears the "new" style leather motorcycle jacket, streamlined and trimmer, with a band collar and racing stripes. © Courtesy Everett Collection.
ABC Custom Leather's yellow racing suit, with a first "Kiss" tag (c. 1960). ABE of Southgate, Los Angeles, was a popular racing gear manufacturer. Note the five-point star design and racing stripes, both typical motifs. © Courtesy Wolf's Head.

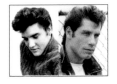

Pre-induction Presley, but with some of the grease removed and his hair coiffed to match his benign expression. © The Kobal Collection.
The classic caricature of Presley. From the tip of his greased D.A. to the soles of his black, studded boots, John Travolta had the look down pat. © Photofest.

Brando doing the unexpected. © Sam Shaw/Roger-Viollet.
Brando shaving and showing off the well-toned physique of his younger years. © Sam Shaw/Roger-Viollet.

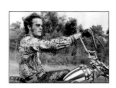

Peter Fonda as Captain America, wearing neo-aviator sunglasses, long sideburns, and a flower-print shirt with his jeans-cut leather pants. © Photofest.

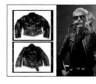

(top) A leather motorcycle jacket, part of a uniform of the German Army during World World II. These were sometimes brought home by Allied troops as souvenirs; (bottom) The classic "Perfecto" leather motorcycle jacket from the 1930s. Irving Schott designed the garment in the preceding decade and named it after his favorite cigar. © Gilles Lohte. Rocker Lou Reed, during a concert in 1974. Heavy metal, heavy drugs, and heavy poetry form the nexus of his life story. © Claude Gassian.

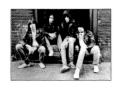

The Ramones, an archetypal punk group, formed in 1974 and was one of the first bands to react to the sentimental pop music of the 1970s by developing a hard-edged sound. © Rue des Archives.

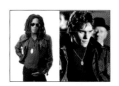

Rocker Lenny Kravitz combines his super-low slung jeans, hippy biker jacket, and jewelry with aviator frames and dreadlocks. © Corbis.
Matt Dillon as Dallas Winston in Francis Ford Coppola's The Outsiders (1983). His disaffected air and teen heartthrob status put Dillon in high demand for rebellious youth roles. © Photofest.

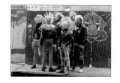

Rebels of a different stripe. The warrior clothes and attitudes first portrayed in The Wild One are still easily discernable here. © Corbis.

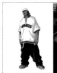

Whards!. Artist Sébastien Pons's illustration epitomizes today's rebel in bold illustrative form. © www.descrient-express.com.
As famous for his lyrical skills as his ability to generate controversy, Eminem has fused the garb of the rebel with his hip-hop fashion. The white undershirt is one of his trademarks. © Rue des Archives.

Bibliography

Bosworth, Patricia. *Marlon Brando.* New York: Lipper/Viking, 2001.

Crane, Diane. *Fashion and Its Social Agendas.* Chicago: The University of Chicago Press, 2000.

Ginsberg, Alan. *Collected Poems 1947–1980.* New York: Perennial, 1988.

Halberstam, David. *The Fifties.* New York: Villard, 1993.

Holley, Val. *James Dean: The Biography.* New York: St. Martin's Griffin, 1995.

Hoskins, Barney. *Montgomery Clift: Beautiful Loser.* New York: Grove Weidenfeld, 1991.

Leland, John. *Hip: The History.* New York: HarperCollins, 2004.

Mailer, Norman. "The White Negro" in *The Beat Generation and the Angry Young Men*, edited by Gene Feldman and Max Gartenberg. Secaucus, New Jersey: Citadel Press, 1984.

Martin, Richard and Harold Koda. *Jocks and Nerds: Men's Style in the Twentieth Century.* New York: Rizzoli, 1989.

McCann, Graham. *Rebel Males.* New Brunswick, New Jersey: Rutgers University Press, 1991.

Pagan, Eduardo Oberegon. *Murder at the Sleepy Lagoon: Zoot Suits, Race, and Riot in Wartime L.A.* Chapel Hill, North Carolina: The University of North Carolina Press, 2003.

Rubinstein, Ruth P. *Dress Codes: Meanings and Messages in American Culture.* San Francisco, California: Westview Press, 1995.

Schickel, Richard. *Brando.* New York: Thunder's Mouth Press, 1999.

Thomson, David. *The New Biographical Dictionary of Film.* New York: Alfred A. Knopf, 2004.

X, Malcolm. *The Autobiography of Malcolm X.* Brattleboro, Vermont: Castle Books, 1964.

Acknowledgments

The publisher would like to thank Cécile Bouvet and Serge Darmon from the Christophe L collection, the photo agencies Corbis, Claude Gassian, Getty, Photofest, Rue des Archives, and the magazine *Wad*.